Twentyville

Ryan Stoute

The Gazer devoured a mermilion.

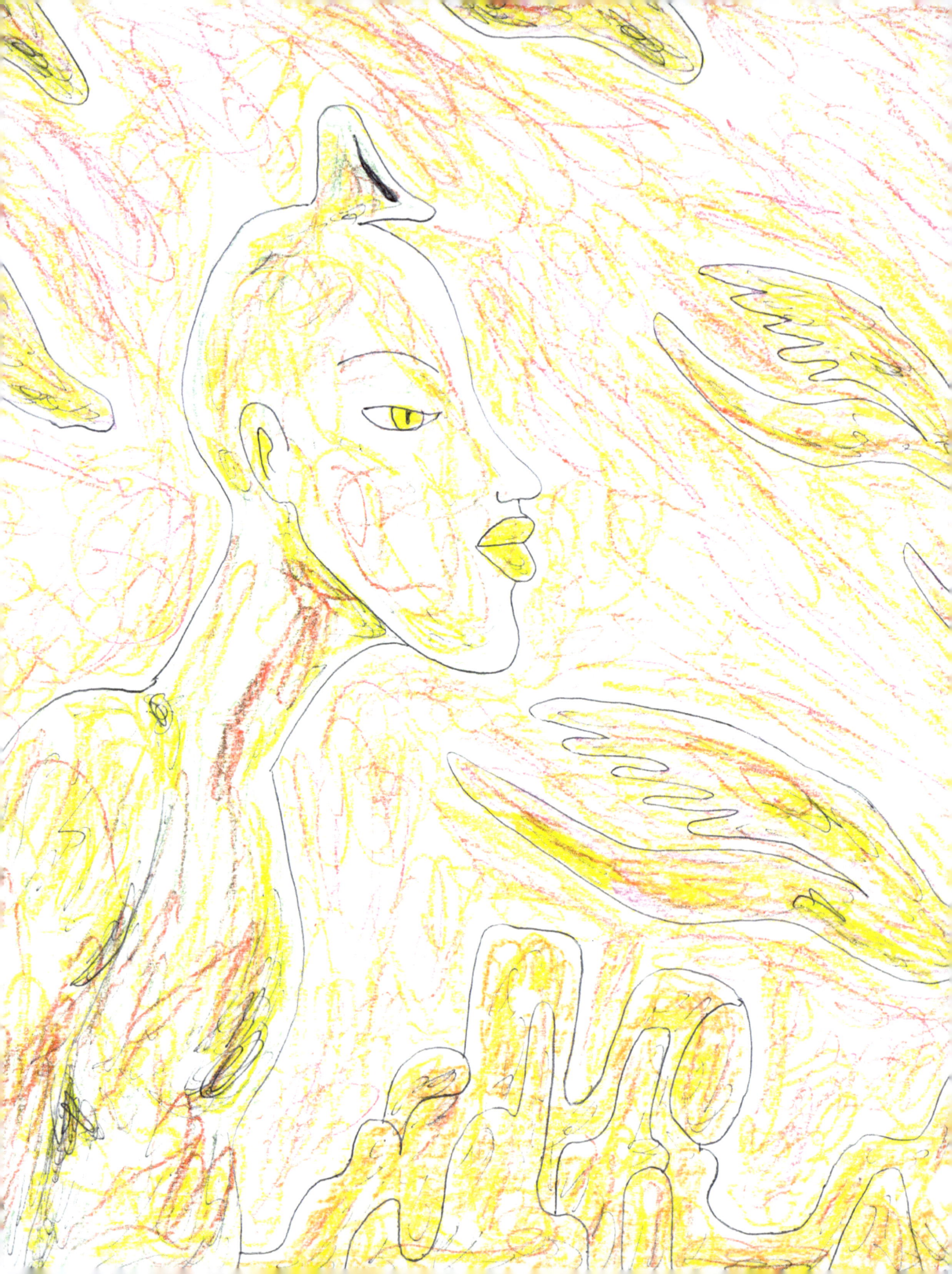

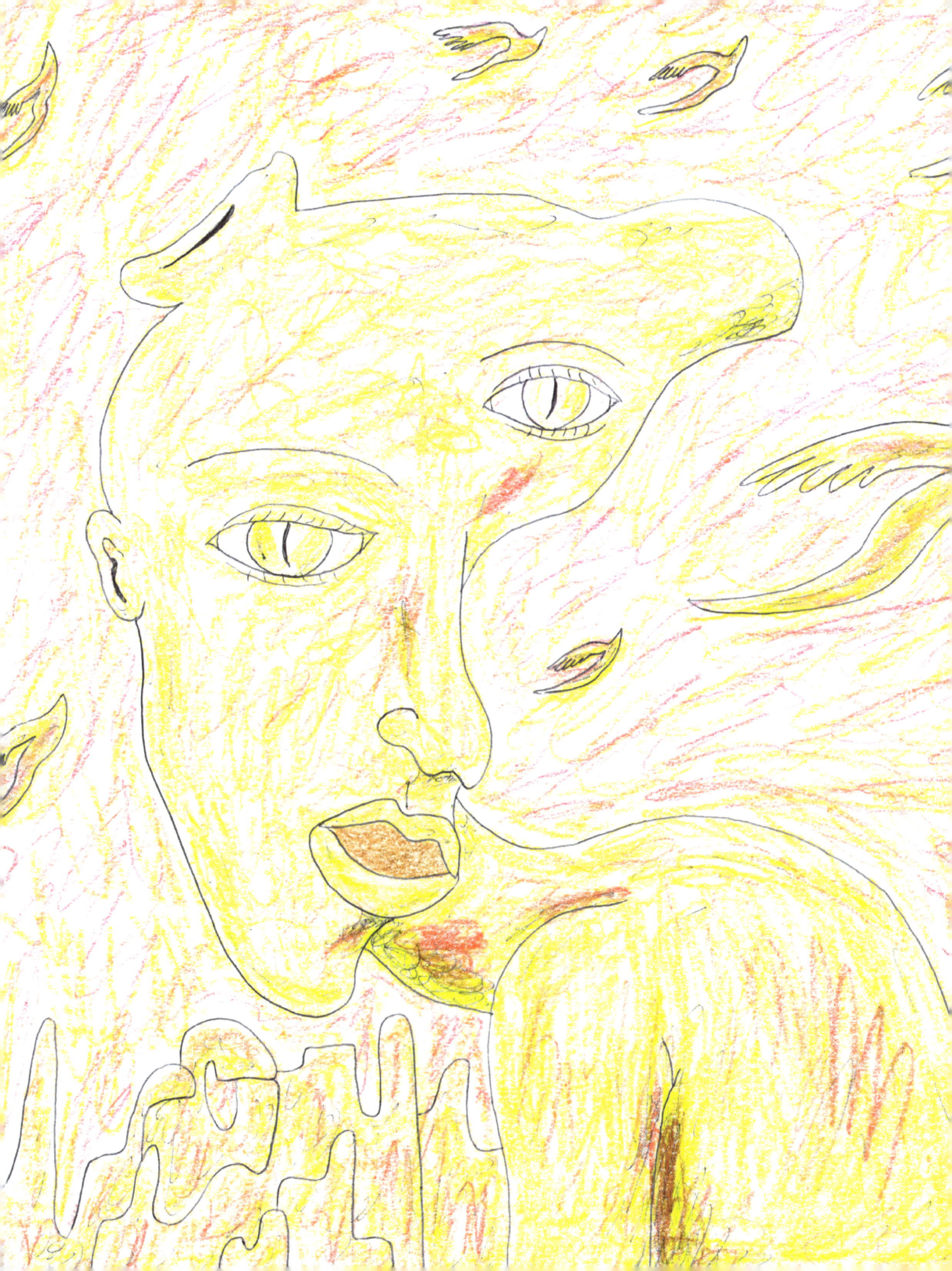

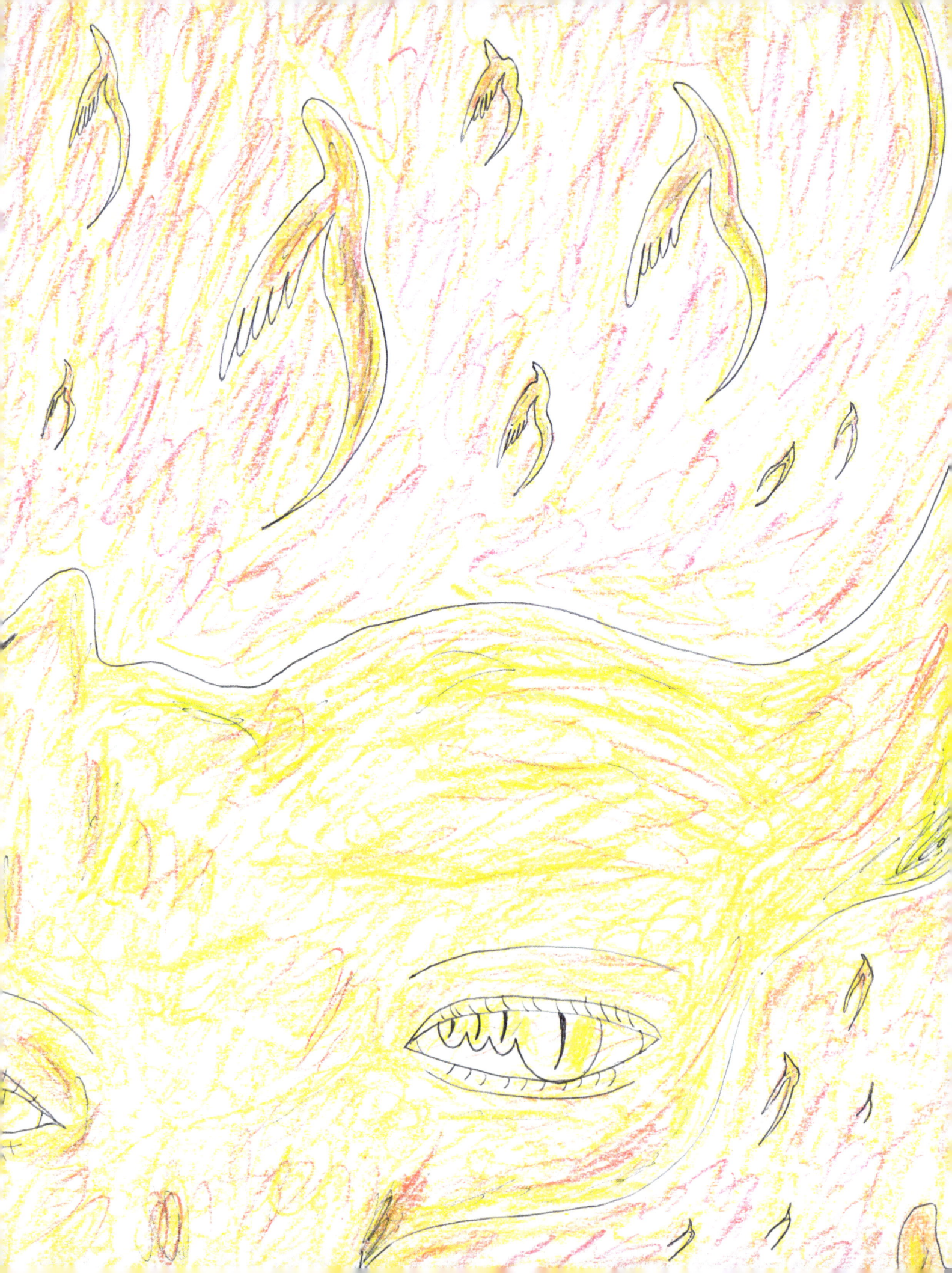

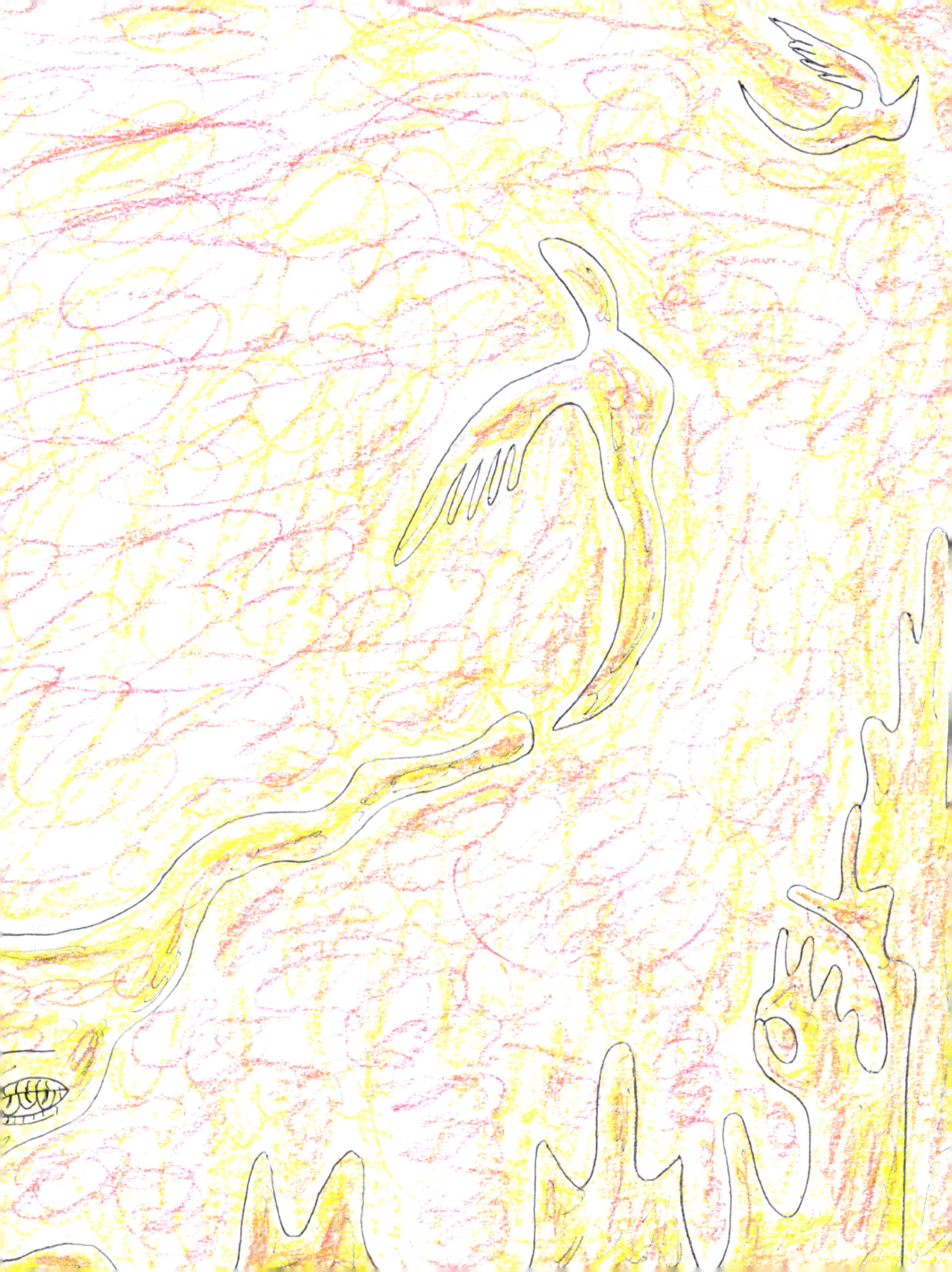

And became the Twentyville, which tore into twenty pieces causing zillions of colorful seeds to pour out.

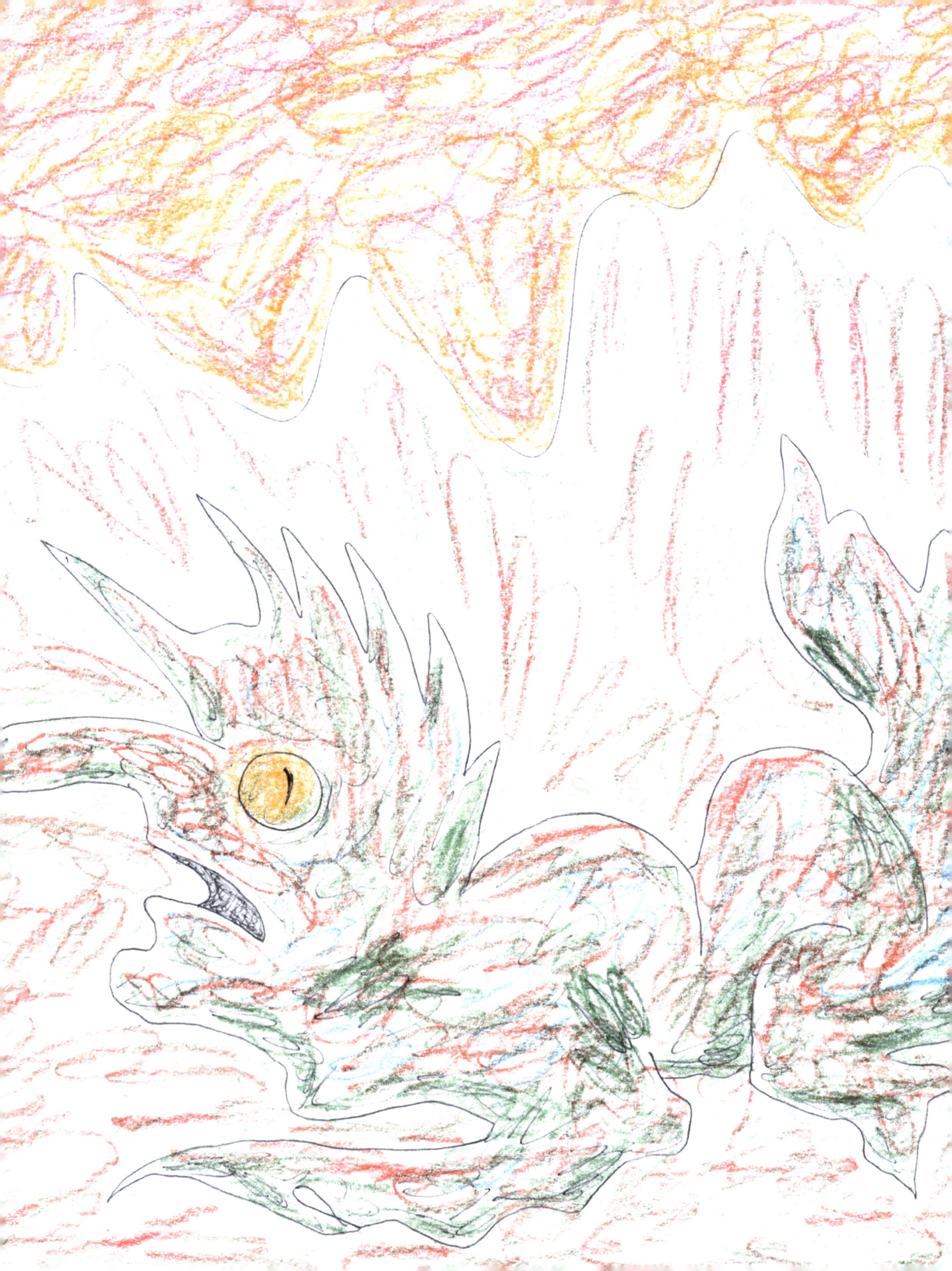

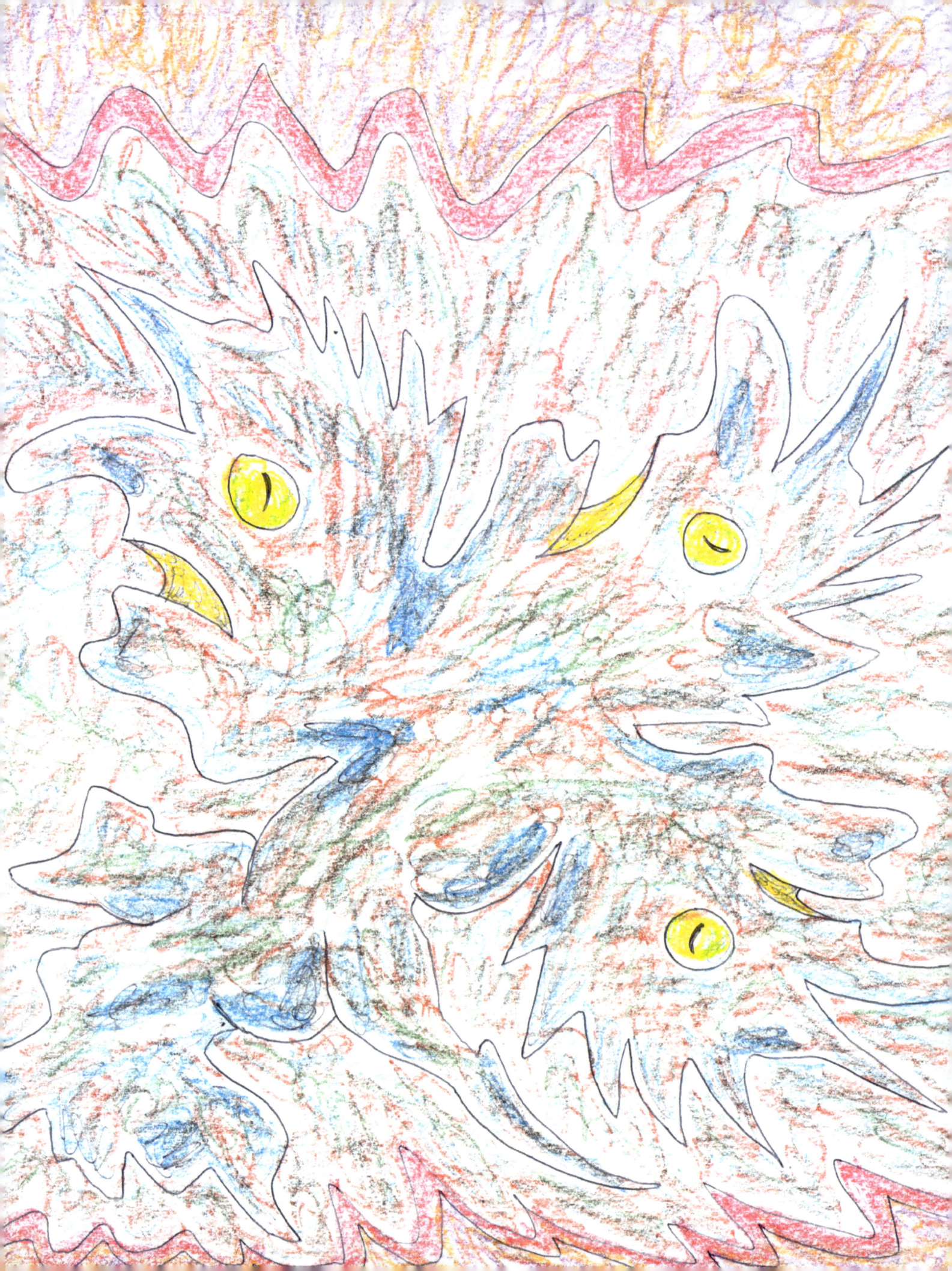

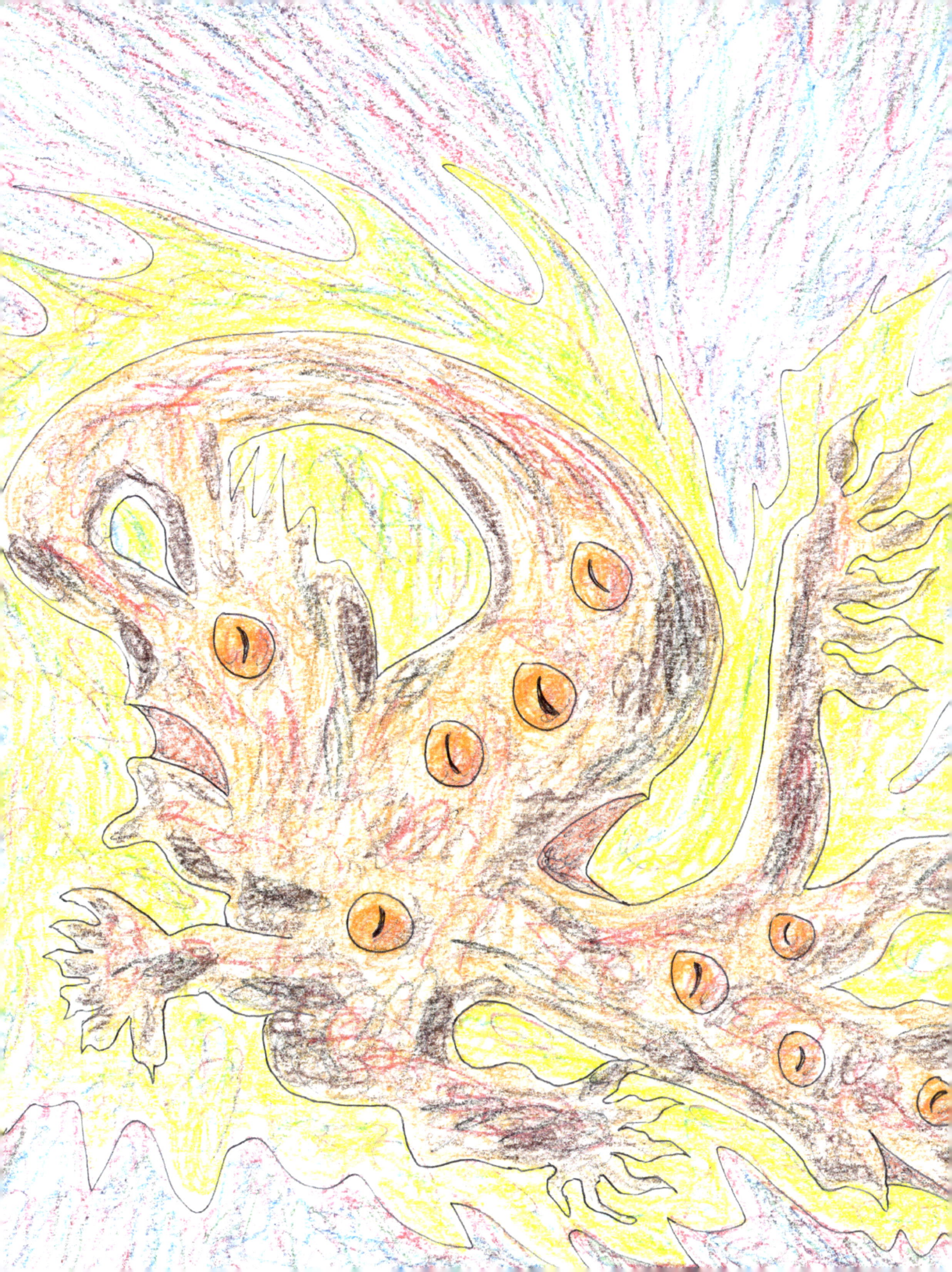

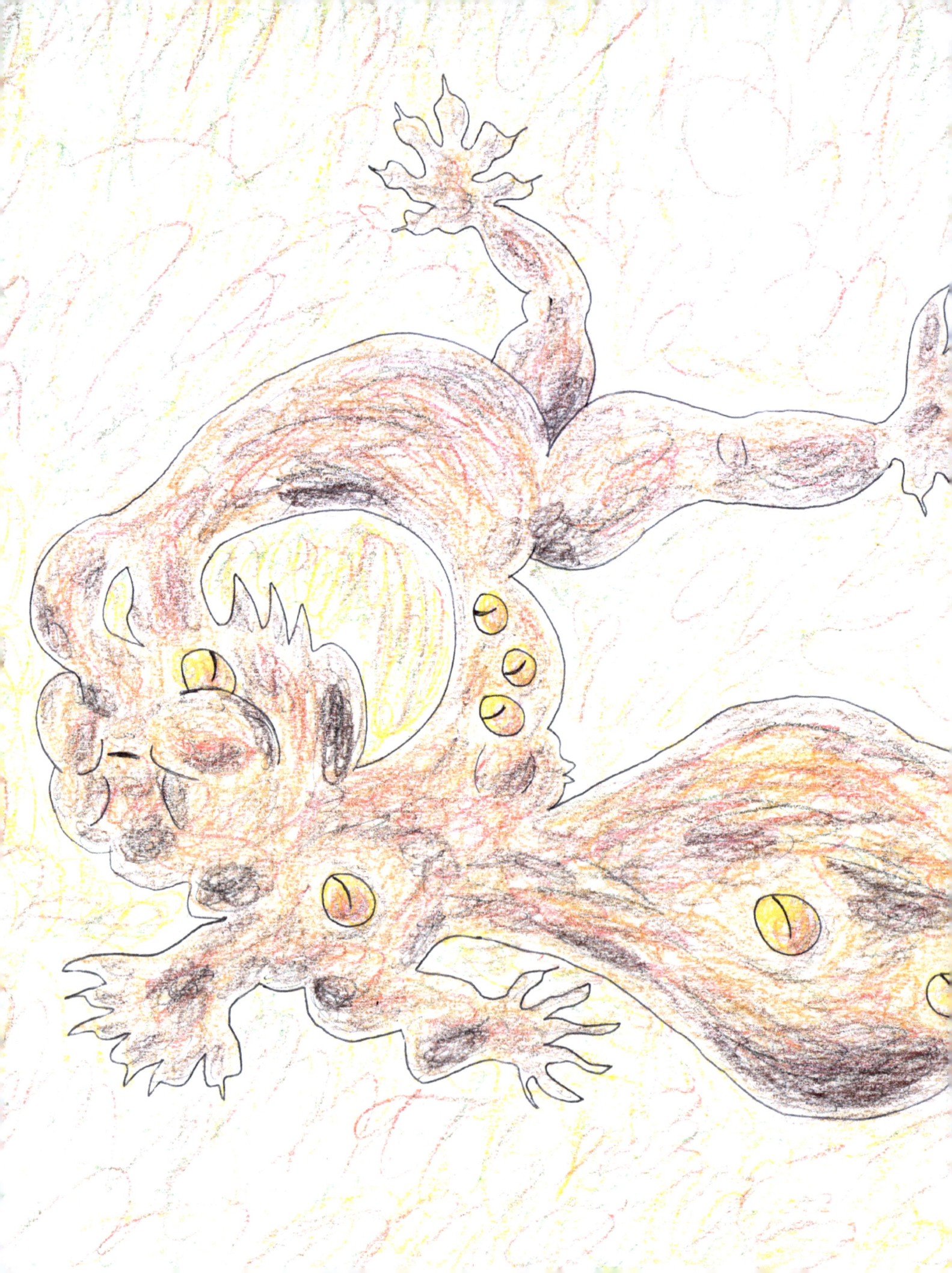

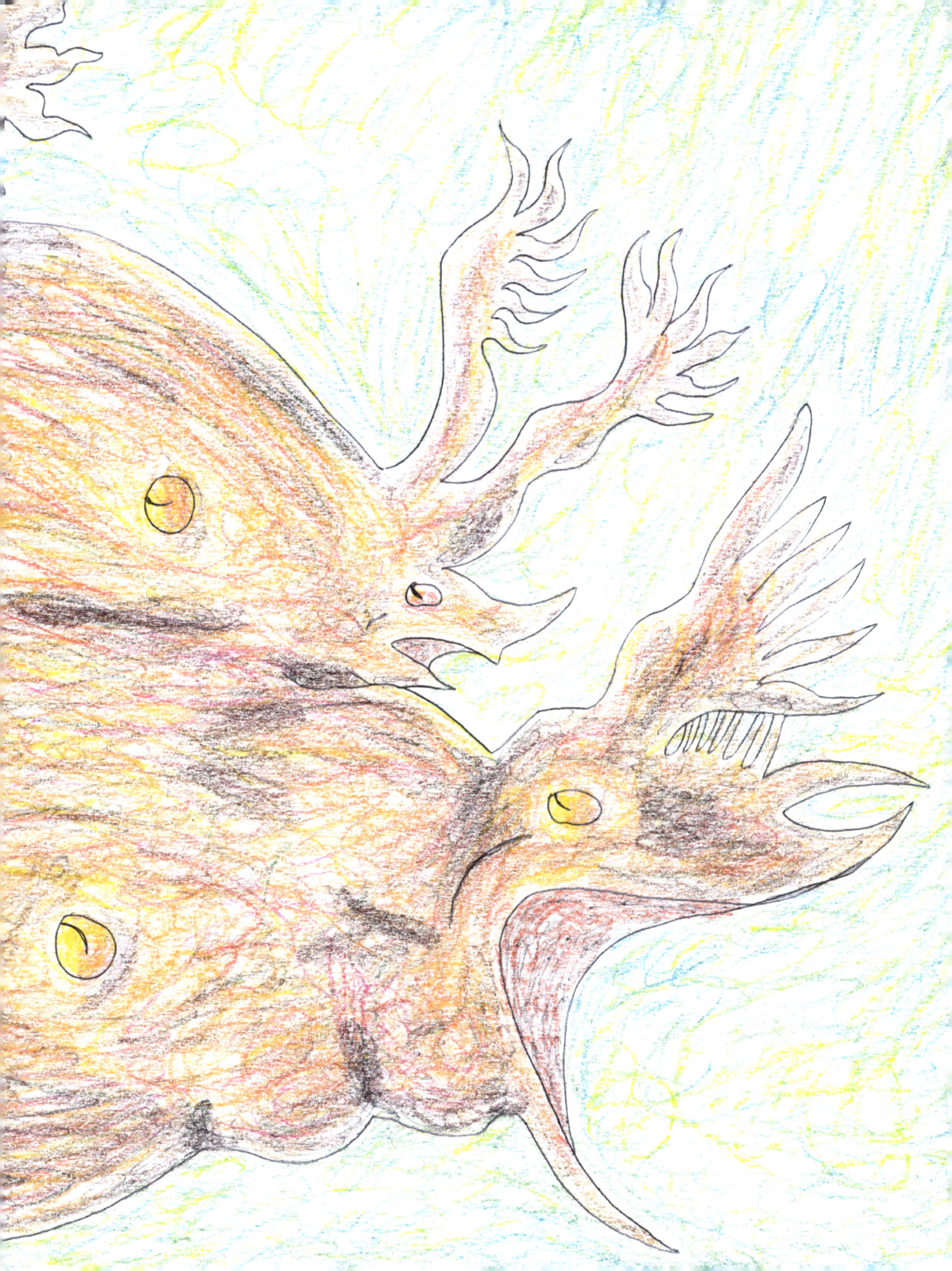

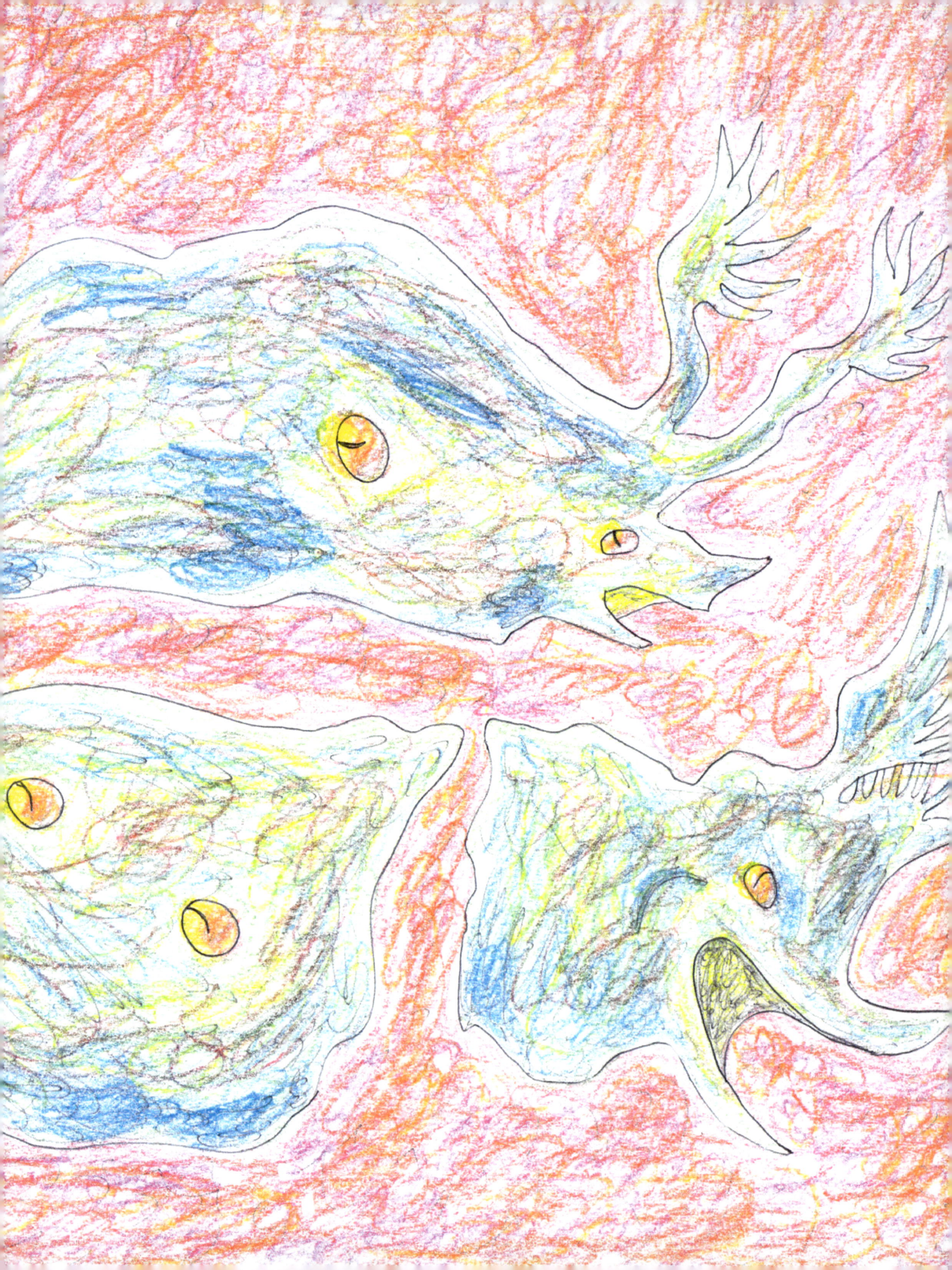

Each of those twenty pieces completely leveled two cities.

In return, the seeds blossomed into brand new cities.

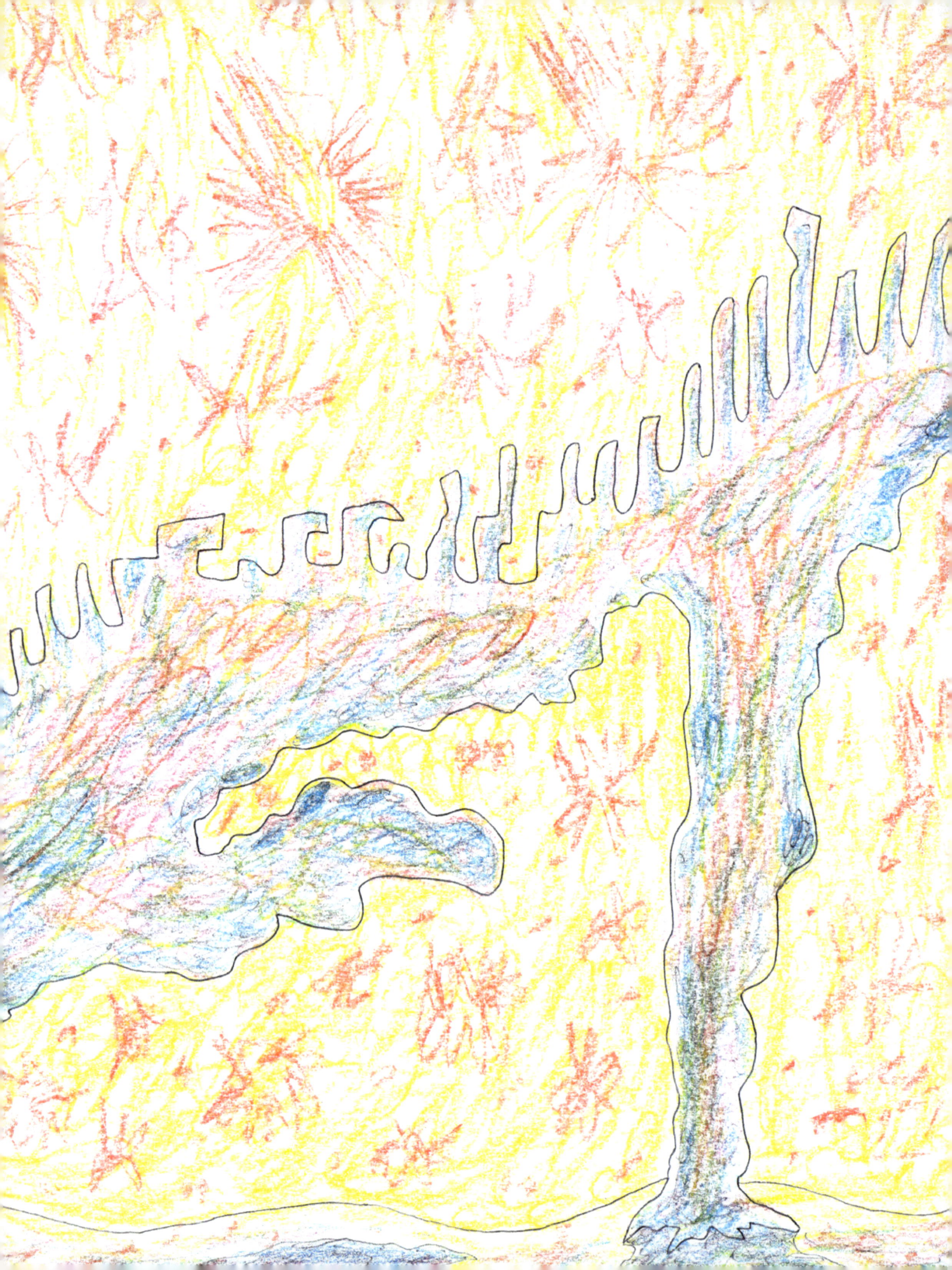

Ryan Stoute is an author of twenty Trafford Publishing books and currently lives in Chelsea, Massachusetts.

Order this book online at www.trafford.com
or email orders@trafford.com

Most Trafford titles are also available at major online book retailers.

© Copyright 2014 Ryan Stoute

All rights reserved. No part of this publication may be reproduced, stored in a retrieval system, or transmitted, in any form or by any means, electronic, mechanical, photocopying, recording, or otherwise, without the written prior permission of the author.

Printed in the United States of America.

ISBN: 978-1-4907-3448-4 (sc)
 978-1-4907-3447-7 (e)

Library of Congress Control Number: 2014907486

Because of the dynamic nature of the Internet, any web addresses or links contained in this book may have changed since publication and may no longer be valid. The views expressed in this work are solely those of the author and do not necessarily reflect the views of the publisher, and the publisher hereby disclaims any responsibility for them.

Our mission is to efficiently provide the world's finest, most comprehensive book publishing service, enabling every author to experience success. To find out how to publish your book, your way, and have it available worldwide, visit us online at www.trafford.com

Any people depicted in stock imagery provided by Thinkstock are models,
and such images are being used for illustrative purposes only.
Certain stock imagery © Thinkstock.

Trafford rev. 4/29/2014

 www.trafford.com

North America & international
toll-free: 1 888 232 4444 (USA & Canada)
fax: 812 355 4082

www.ingramcontent.com/pod-product-compliance
Lightning Source LLC
Chambersburg PA
CBHW040755200526

45159CB00025B/2597